A
flow
BOOK

know
yourself

A BOOK OF QUESTIONS

IRENE SMIT
and
ASTRID VAN DER HULST

Workman Publishing • New York

Library of Congress Cataloging-in-Publication Data is available.
ISBN 978-1-5235-0635-4

Design by *Flow* magazine and Lisa Hollander
Text by Danielle Bakhuis
With special thanks to Caroline Buijs

Workman books are available at special discounts when purchased in
bulk for premiums and sales promotions as well as for fund-raising or
educational use. Special editions or book excerpts can also be created
to specification. For details, contact the Special Sales Director at the
address below, or send an email to specialmarkets@workman.com.

Workman Publishing Co., Inc.
225 Varick Street
New York, NY 10014-4381
workman.com

flowmagazine.com

Printed in China
First printing March 2019

10 9 8 7 6 5 4 3 2

LIFE IS NOT ABOUT
FINDING THE RIGHT ANSWERS;
IT'S ABOUT ASKING THE RIGHT QUESTIONS.

—UNKNOWN

*

Many wise people have uttered similar sentiments over the years, but this wording struck us as particularly intriguing. A good question makes you think; it opens windows in your mind and can help focus your thoughts. Sometimes a question can be quite confrontational. Sometimes it can inspire an idea. We filled the following pages with questions you can ask yourself. Some are simple, some are surprising, some are odd. Some may have obvious answers and others may challenge you to really think. It doesn't matter whether or not you can come up with answers. The point is to stay curious and keep asking questions. Who knows what you will learn in the process . . .

Enjoy!

Irene & Astrid

when did
you last
do something
for the first
time?

what can you not throw away?

what's your favorite room in your house?

when
are you
at your
best?

how do
you cheer
yourself
up after a
bad day?

what do
you think
about
before you
fall
asleep?

zᶻᶻ

are you
more at home
in a town
or in a big
city?

what makes you laugh?

what have
you recently
changed
your mind
about ?

would you rather have a different name?

do you give people a second chance?

how do you spoil yourself?

how
many
homes
have you
lived in?

which family member do you most resemble?

what's

your

favorite

sound?

how would you fill your days if you could do anything you wanted to do?

what do
you like
daydreaming
about?

do you always order the same thing at restaurants?

do you find
it easy
to admit
your
mistakes?

do you like being in the spotlight?

which historical event do you wish you could have seen with your own eyes?

do you like being alone?

what color dominates your wardrobe?

if you could start your own business, what would it be?

what song
always
makes you
feel happy?

do your
personality
traits
match your
zodiac sign?

can you
let go
of things
easily?

what's your biggest dream?

do you
always
celebrate
your
birthday?

who or
what
is in your
favorite
photo?

how would
people
describe
you on
first sight?

what book did you recently finish with a big sigh?

what's the best thing about being an adult?

who do
you go to
for wise
advice?

how old
do you
feel ?

have you ever gone swimming at night?

what were the three best things that happened today?

what do
you do when
you're
nervous?

what can
you put off
until
tomorrow?

Whom can you talk to for hours about nothing in particular?

what do you
still want
to learn?

are you a good storyteller?

what's your favorite flower?

have you ever been to a legendary party?

what's the best thing about coming home?

what's
your
greatest
victory?

what do
you do
when
things don't
work out?

what would
be the title
of your
autobiography?

do you like being surprised?

can
people
change?

which of your five senses is the strongest?

which of
your
homemade
desserts is
always a
success ?

how do you let people know they are special to you?

what's the wildest thing you've ever done?

what are
you grateful
to your
Parents for?

what work
of art has
made the
greatest
impression
on you?

which ocean did you last swim in?

what do
you sing in
the shower?

what would you do with an extra hour each day?

what do
most people
not know
about
you?

where's the
strangest
place you've
ever
woken up?

what's the last picture you took?

do you believe in life after death?

what do
you do
when you
get lost
somewhere?

what's the worst thing you did as a kid?

what was
the best advice
that anyone
ever gave
you?

what do you always have in your fridge?

what's
your next
project?

what story
has been
making the
rounds in
your family
for years?

have you looked at the clouds today?

what
poem do
you find
beautiful?

would you
go back to
life
without the
internet?

what would you wear on the red carpet?

what word do you use too often?

have you
ever received
a love letter?

have you
ever written
a love letter?

what have
you recently
said no to
with deep
regret ?

when does
your ego
get in
the way?

what do
you hold on
to when
times are
hard?

do you
prefer to
work on your
own or with
others?

do you ever fantasize about being famous?

do you find it easy to ask for help?

what scent immediately reminds you of the past?

which
people from
your past
are still
in your
heart ?

what has made you doubt yourself?

what would you do if you didn't have to work?

when have
you stood
up for
yourself?

what makes your home feel like home to you?

what word
gives you
the
jitters?

what song
lyrics have
pulled
you through
heartbreak?

what dish would you like to eat every day?

do you
practice
what you'll
say before
making a
phone call?

how do
you decide
whether
you like
someone?

what do
you do when
you can't
sleep?

z^z^z

how important are other people's opinions when you're deciding on something?

what have
you only
recently
discovered?

what
color would
you give
your
life?

who was your first best friend?

do you
always
say
what
you think?

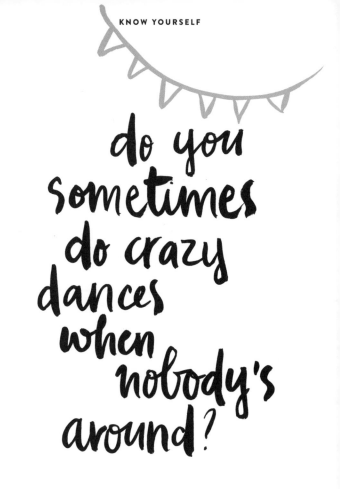

do you
sometimes
do crazy
dances
when
nobody's
around?

what's the strangest thing you've ever eaten?

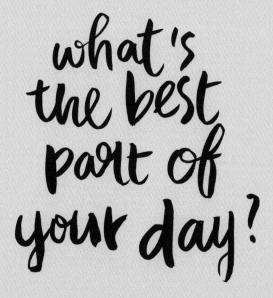

what trait
do you really
appreciate
in a
loved
one?

what's
the last
time you
held a
baby?

When did
you last spend
a whole
day outdoors?

what is
your favorite
thing to
do on a
night
out ?

what would you never do again?

which
teacher has
had a
positive
influence
on you?

do you
forgive
people
easily?

are you
kind to
yourself?

are you
holding on
to something
you should
have let go
of long ago?

are you
a good
loser?

what superpower would you like to have?

what's on your bedside table?

what's the biggest gamble you've taken?

what's the first thing you do in the morning?

are you
good
at your
job?

when was the last time you saw a sunrise?

what did
you think
would never
happen to
you?

Which do you say more often — yes or no?

when did you last spend a whole day doing nothing?

what role
do you play
in your
circle of
friends?

what made you happy when you were younger?

what
useless
talent
do you
possess?

what things are still on your to-do list?

what has
given you
the most
grief?

what dish do you regularly serve your guests?

what's made you giggle lately?

what
gives
meaning
to your
life?

what anecdote about yourself do you often hear?

what was a turning point in your life?

is there something that you don't dare to admit to yourself?

what is
absolutely
essential
to a good
party?

do you
usually follow
your heart
or your
head?

how close are you to being who you want to be?

which day
of your life
would you
like to
relive?

do you ever take long walks by yourself?

have you
ever made
a speech?

Can you laugh at yourself?

what did you learn in school that you still find useful?

what would
you say to
your
younger
self?

what would
you like
to ask your
future self?

what theme would you choose if you were to throw a costume party?

what does your ideal day look like?

what's your favorite reward for hard work?

what unwritten rule do you follow at all times?

when was the last time you flirted with someone?

when was
the last time
you felt
sand between
your toes?

who has
surprised you
lately?

whom did you
last send
a card to?

what are
the little
things in
life that
you enjoy?

what's your favorite season?

what's
your
greatest
weakness?

would you
like to live
in another
country?

what movie have you seen at least five times?

do you
tend to
ask the
questions
or answer
them?

what would
the painting
of your
life look
like?

What do you like doing most on a rainy afternoon?

what would
you do if
nothing
could possibly
go wrong?

have you
ever been
disappointed
in someone?

how often
do you write
by hand?

where do
you feel at
peace?

ABOUT THE AUTHORS

Irene Smit and **Astrid van der Hulst** are the creative directors of *Flow* magazine, a popular international publication packed with paper goodies and beautiful illustrations celebrating creativity, imperfection, and life's little pleasures. Irene and Astrid began their magazine careers as editors at *Cosmopolitan* and *Marie Claire*. In 2008, inspired by their passion for paper and quest for mindfulness, they dreamed up the idea for their own magazine in a small attic. They are now the coauthors of five books, including *A Book That Takes Its Time*, *The Tiny Book of Tiny Pleasures*, and *Creativity Takes Courage*. They each live with their family in Haarlem, Netherlands. To see more of their work, visit flowmagazine.com.

Milou Curvers provided all the hand lettering for this book (she's nicknamed *Mevrouw Knot*—Dutch for "Miss Topknot"— because that's how she always wears her hair). She used four pots of India ink and 337 sheets of paper while painting all the questions with a round brush (size 5). Milou studied graphic design at the Willem de Kooning Academy in Rotterdam, Netherlands. To see more of her work, visit mevrouwknot.nl.